Who Pooped in the Park?

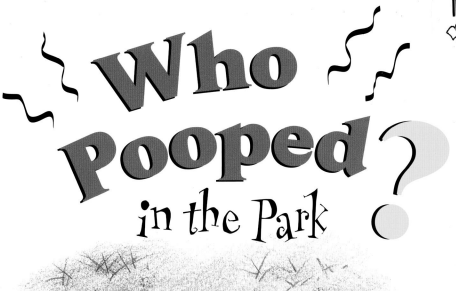

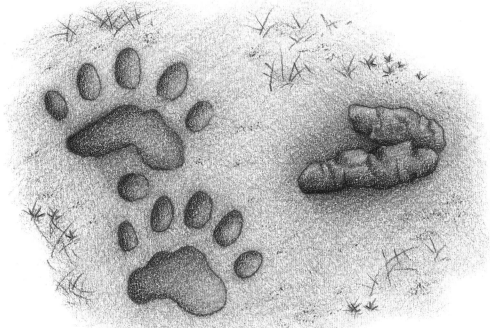

written by Gary D. Robson • illustrated by Elijah Brady Clark

FARCOUNTRY
PRESS

To the first editor who decided my writing was good enough
to pay for, Jerry Werner. Thanks for kick-starting my writing
career at *VLSI Design Magazine* twenty years ago.

ISBN 10: 1-56037-319-9
ISBN 13: 978-1-5603-319-3

© 2005 Farcountry Press

For more information about our books, write
Farcountry Press, P.O. Box 5630, Helena, MT 59604;
call (800) 821-3874; or visit www.farcountrypress.com.

Created, produced, and designed in the United States.

Manufactured by
Bolvo Yuanzhou Midas Printing Ltd.
Bolvo Yuanzhou Town Xianan Administration District
Guangdong, PRC
in May 2011
Printed in China.

15 14 13 12 11 5 6 7 8 9

"Dad? I have to go to the bathroom."
Michael squirmed in the back seat.

"We'll be at our campground in just a
little while," said Dad. "We're in Grand
Canyon National Park now."

"He's just nervous," said Michael's sister. "He thinks a mountain lion's gonna eat him." She growled at Michael and made her fingers look like claws.

"Stop it, Emily," said Mom. "Nobody is getting eaten by anything."

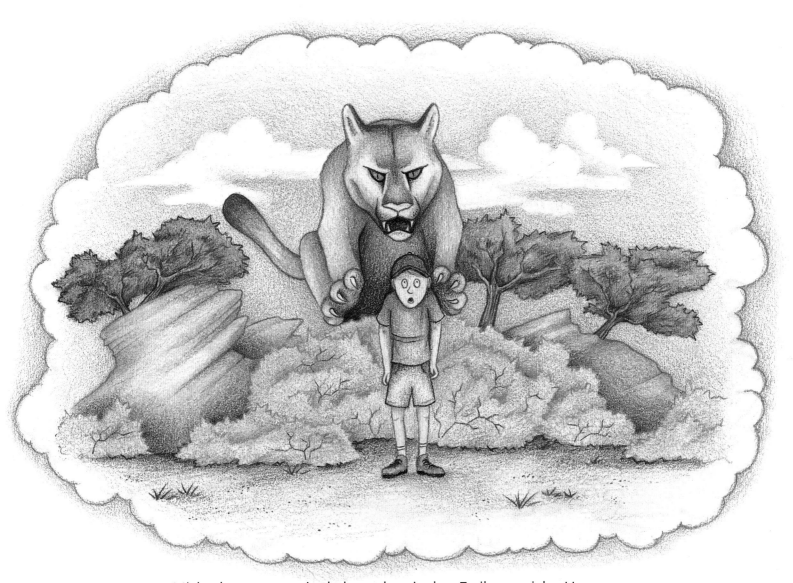

Michael was very excited about the trip, but Emily was right. He *was* nervous. He had just read a book about big cats, and mountain lions scared him. He was afraid that a hungry mountain lion would eat just about anything—maybe even a boy.

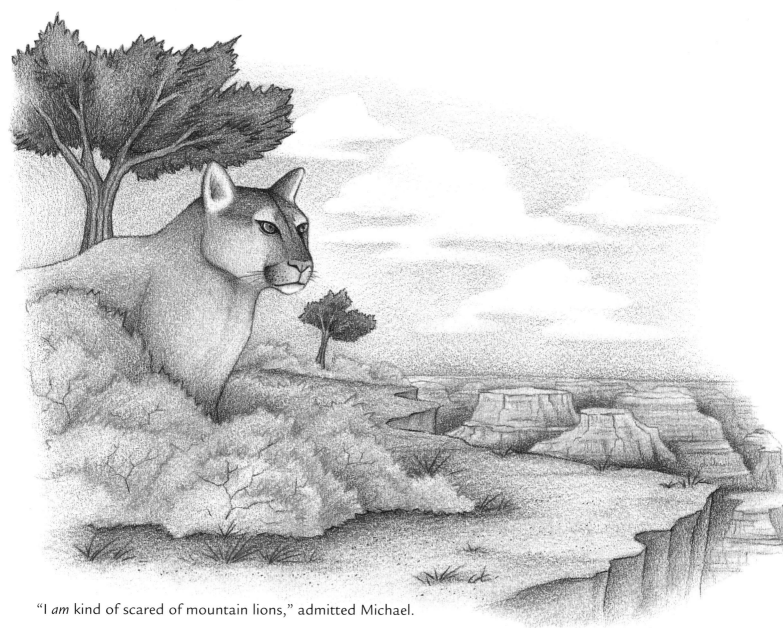

"I *am* kind of scared of mountain lions," admitted Michael.

"Don't worry," Dad told him. "Mountain lions tend to stay away from people. Besides, we're going to show you how to learn all about them without ever getting close!"

"Here's our campsite. Let's set up the tent. Then we can go for a walk and I'll show you what I mean," Dad said. Michael was awfully worried about mountain lions, but tried not to show it.

"Let's hurry!" said Emily. "I want to see some animals!"

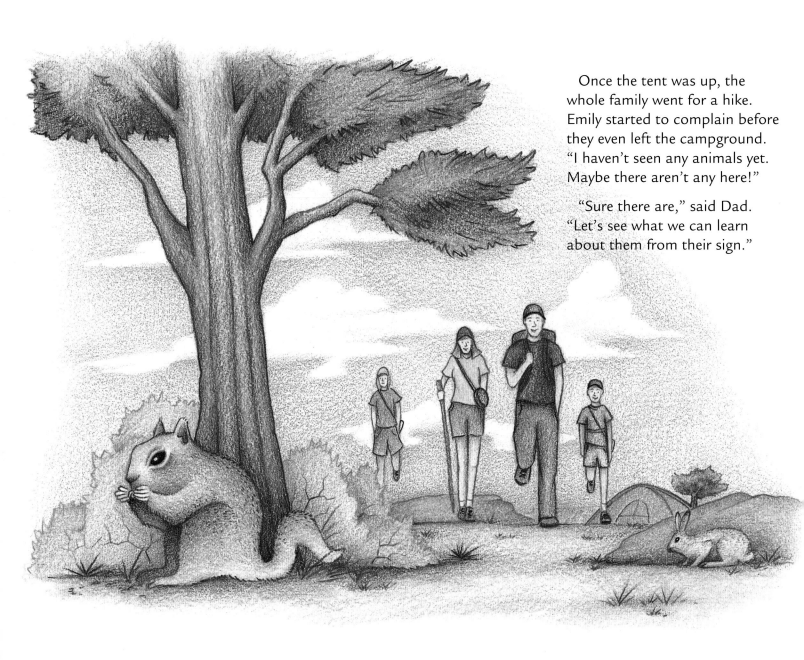

Once the tent was up, the whole family went for a hike. Emily started to complain before they even left the campground. "I haven't seen any animals yet. Maybe there aren't any here!"

"Sure there are," said Dad. "Let's see what we can learn about them from their sign."

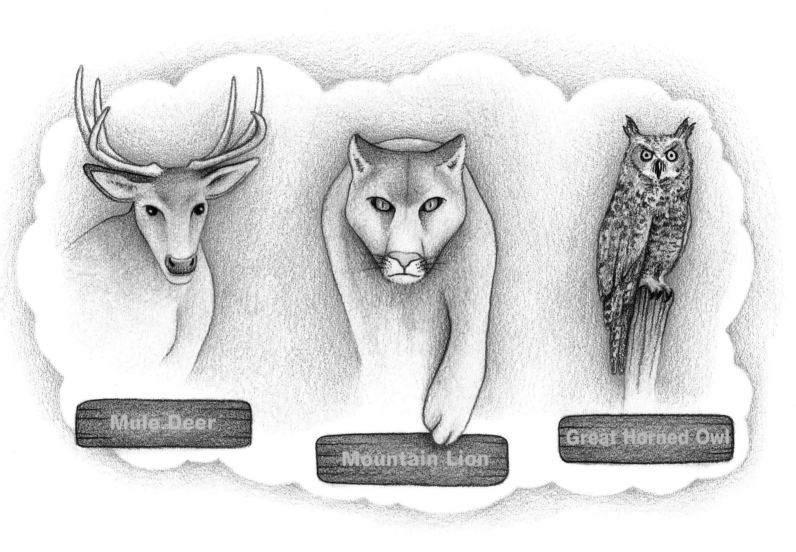

Mule Deer

Mountain Lion

Great Horned Owl

"Sign?" said Michael. "You mean like a sign at the zoo?"

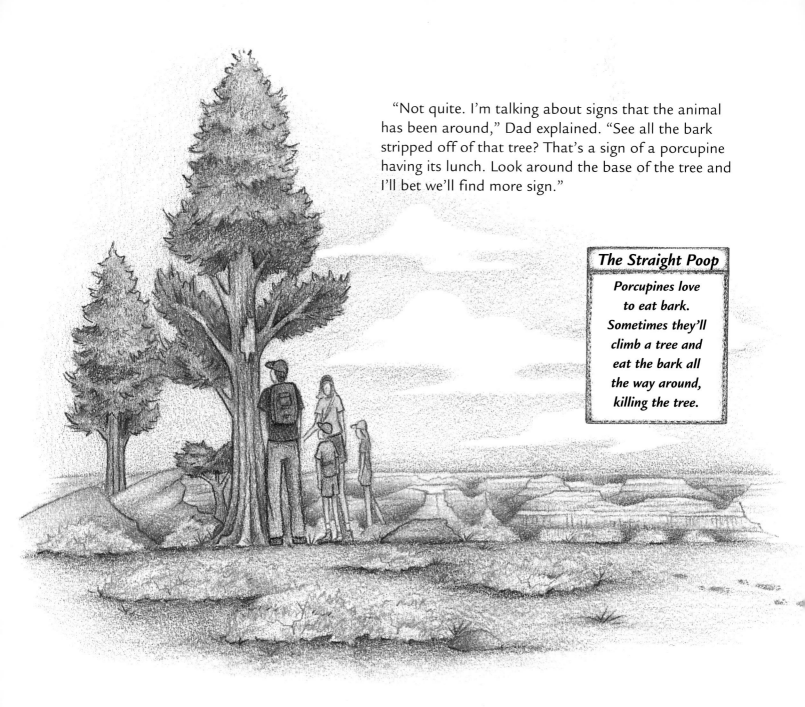

"Not quite. I'm talking about signs that the animal has been around," Dad explained. "See all the bark stripped off of that tree? That's a sign of a porcupine having its lunch. Look around the base of the tree and I'll bet we'll find more sign."

The Straight Poop

Porcupines love to eat bark. Sometimes they'll climb a tree and eat the bark all the way around, killing the tree.

Michael was starting to get excited. "Look! I found tracks!"

"Yes," said Mom. "Those are porcupine tracks. See the marks where he dragged his tail behind him?"

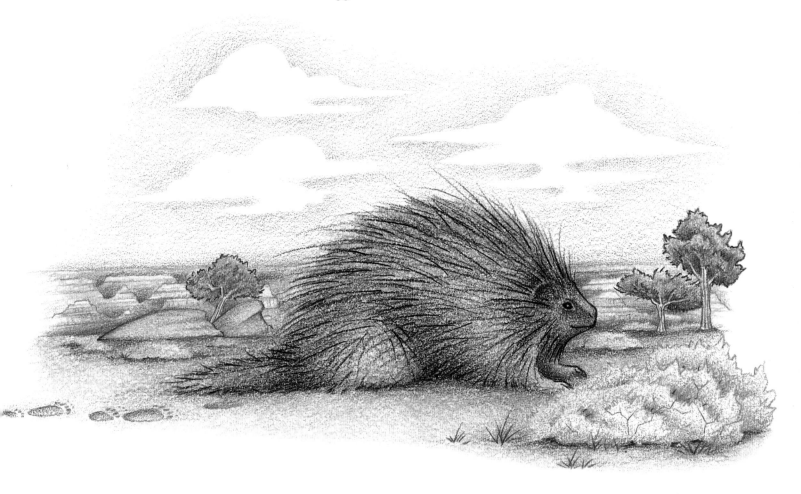

"And there's porcupine scat over here," said Dad.

"Scat?" asked Emily, looking a little less grumpy. "What's scat?"

"It's the word hikers and trackers use for animal poop," Dad replied.

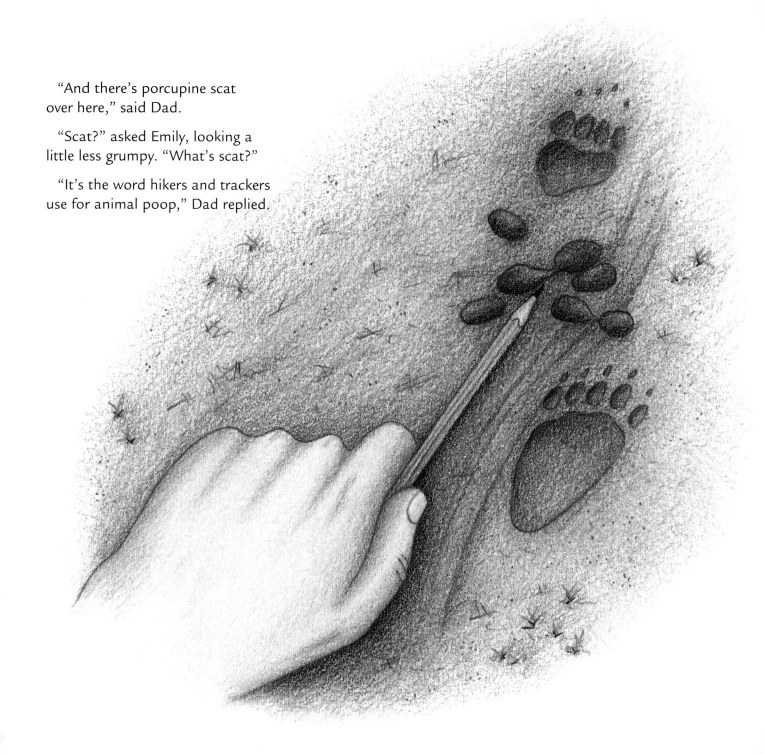

"See, Michael," said Dad. "We don't have to get up close to an animal to learn about it. Instead of a close encounter of the *scary* kind, we'll have a close encounter of the *poopy* kind."

Everybody laughed, and Mom made a gross-out face.

"Dad! Mom! Look over here! I found bunny scat!" yelled Michael. "It's just like what we have in Fluffy's cage."

"We came all the way to Grand Canyon National Park for *that*?" grumbled Emily. "Michael's bunny makes plenty of poop at home."

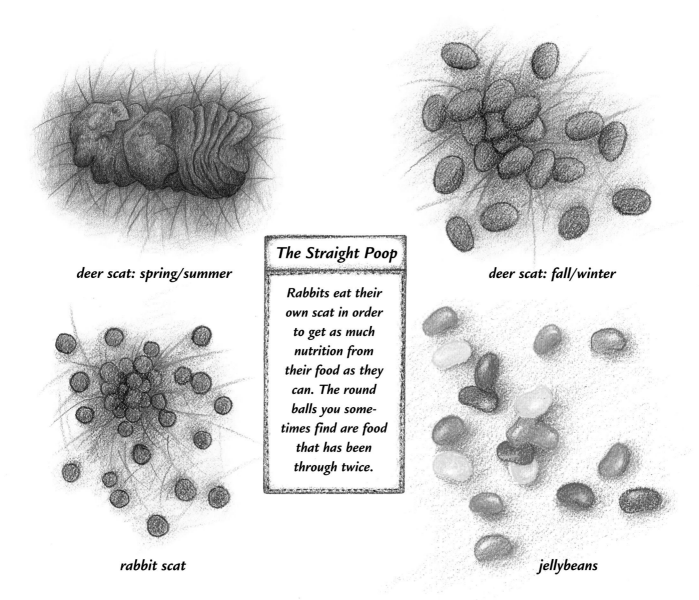

deer scat: spring/summer

deer scat: fall/winter

The Straight Poop

Rabbits eat their own scat in order to get as much nutrition from their food as they can. The round balls you sometimes find are food that has been through twice.

rabbit scat

jellybeans

"Good, Michael! And there's deer scat over here, too!" said Mom.

"How can you tell the difference?" asked Michael.

"Bunny scat looks like little round balls," added Dad. "Deer scat is shaped more like jellybeans."

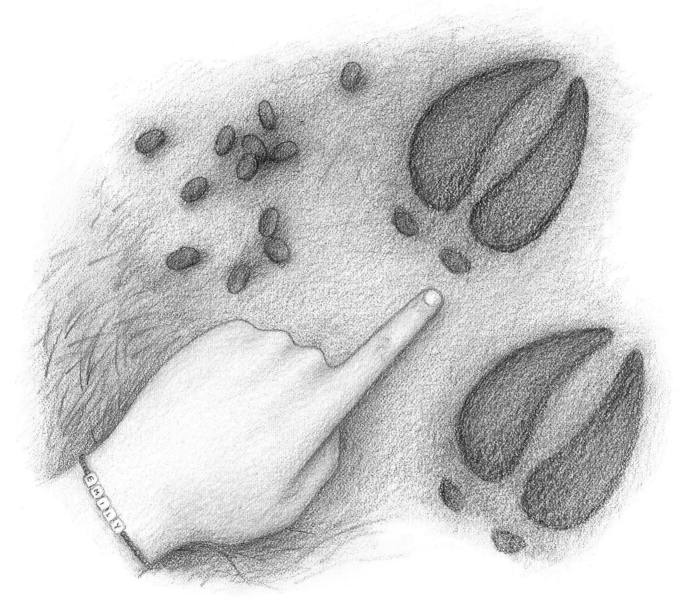

"Are these deer tracks?" Michael asked.

"Yes!" said Mom. "See how they're split? They have hooves with two parts."

"What are these marks?" asked Emily. She was starting to get interested.

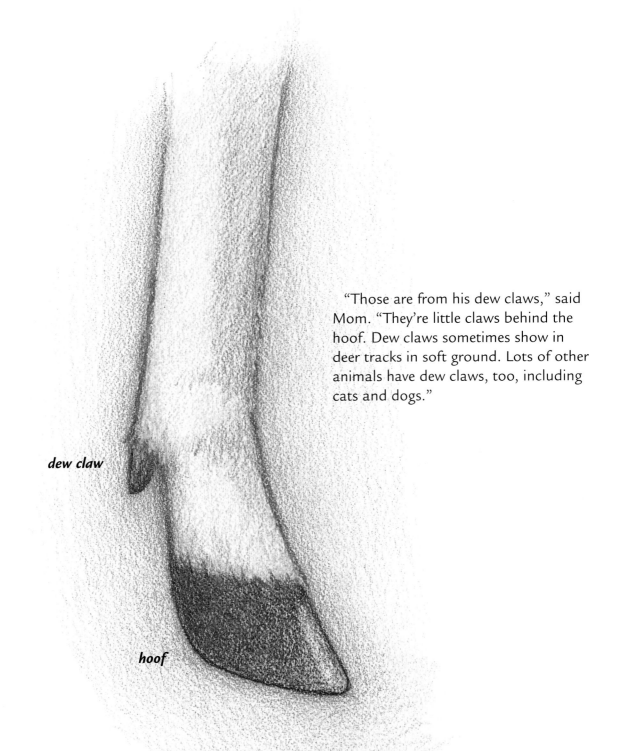

dew claw

hoof

"Those are from his dew claws," said Mom. "They're little claws behind the hoof. Dew claws sometimes show in deer tracks in soft ground. Lots of other animals have dew claws, too, including cats and dogs."

"Oh, no!" said Michael. "Here's one of his antlers. Did a mountain lion eat him?" Michael looked around nervously.

Dad bent down by the antler. "No, he's fine. Deer shed their antlers every winter and then grow a new, bigger set the next year."

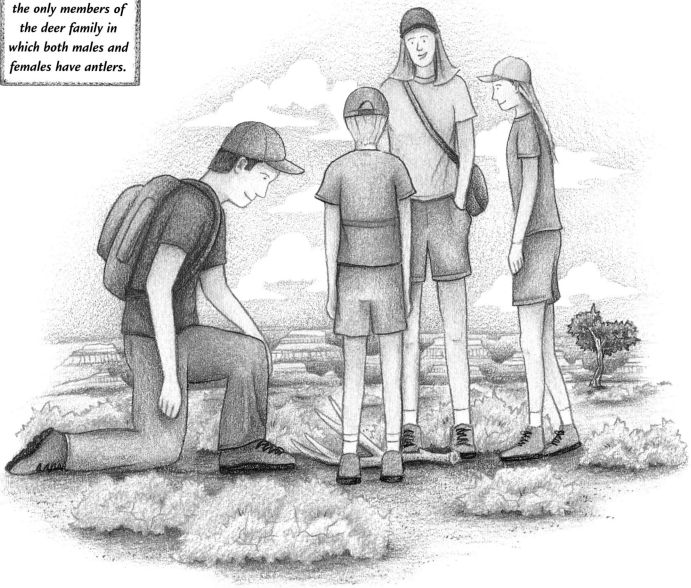

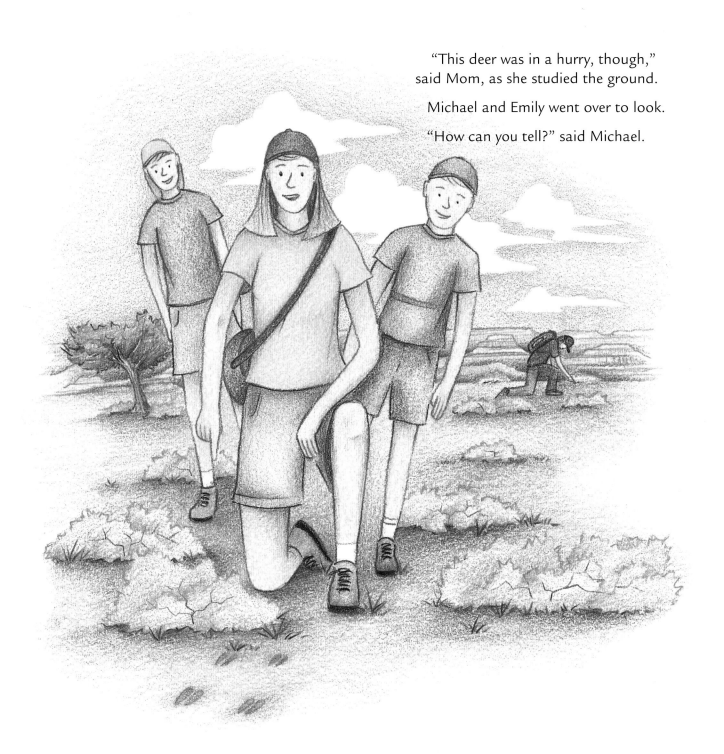

"This deer was in a hurry, though,"
said Mom, as she studied the ground.

Michael and Emily went over to look.

"How can you tell?" said Michael.

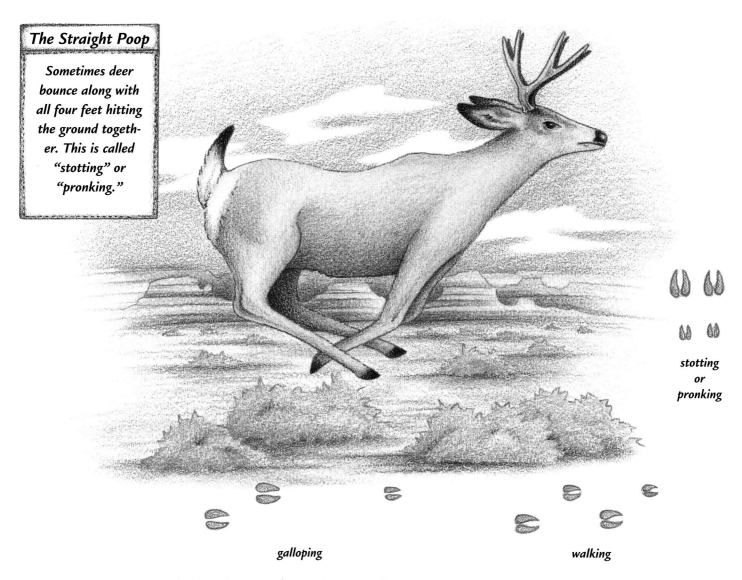

The Straight Poop

Sometimes deer bounce along with all four feet hitting the ground together. This is called "stotting" or "pronking."

stotting
or
pronking

galloping

walking

"The hoofprints get very far apart here," Mom explained, "and the back prints are in front of the front prints."

"He was walking backwards?" said Emily.

Mom replied, "No, he was galloping. Something scared him and he was moving fast."

"I know what scared him," Dad called.

The family hurried over to look.

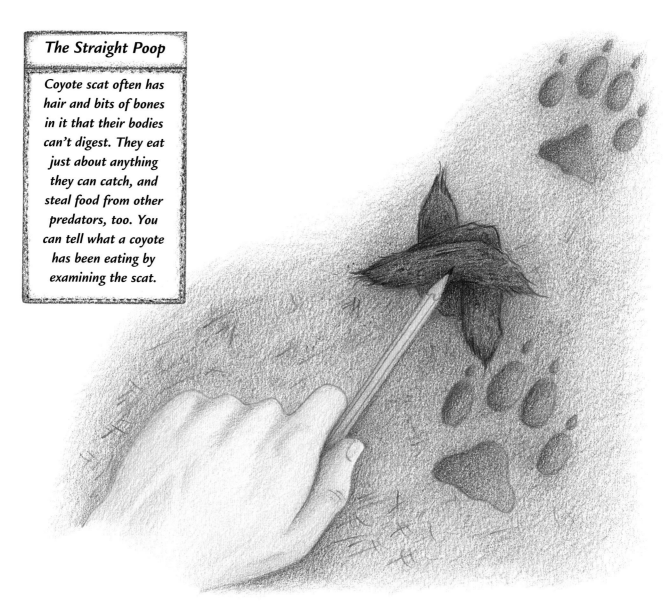

"This is coyote scat," Dad said, "and there are coyote tracks all around here."

"They look like dog tracks," said Michael.

"That's because the coyote is a member of the dog family," explained Dad.

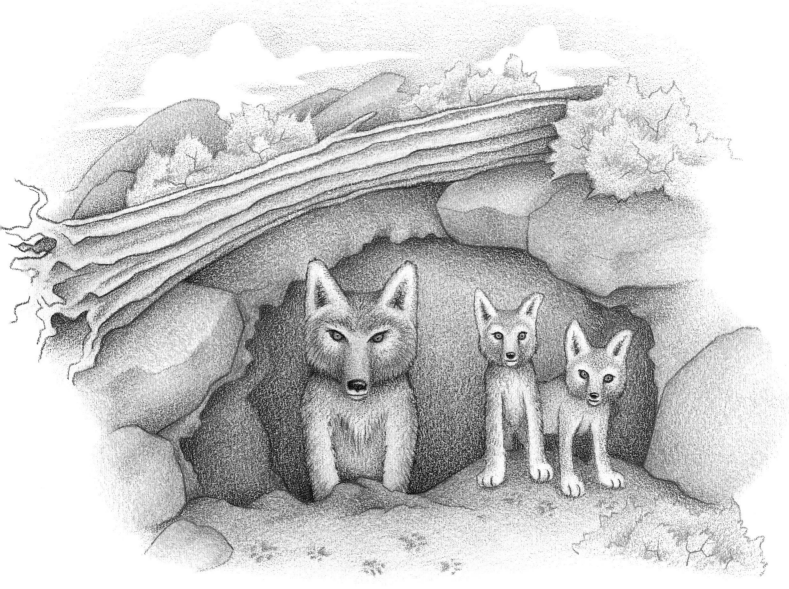

"There were a lot of coyotes around here," said Mom. "See how the adults left big tracks and the pups left smaller ones?"

"Their den is probably nearby. I'll bet they scared the deer away," Dad guessed.

"Did the coyotes get him?" Michael asked.

"I don't think so," said Mom. "Look! The deer are over there, and so are the coyotes."

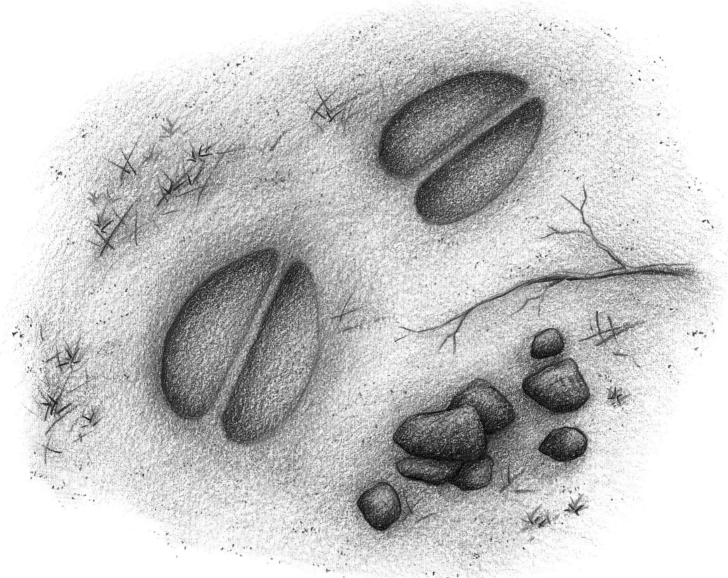

"Here are some other tracks to take a look at," Dad said.
"They're like deer tracks, but a lot smaller, and not as pointy."

"What are they?" Emily asked.

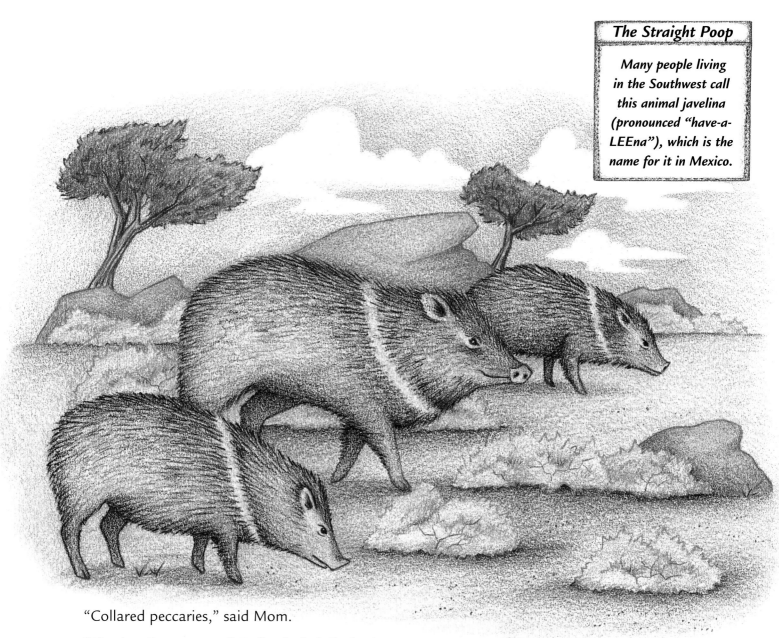

"Collared peccaries," said Mom.

"That's a funny name," Emily giggled. "What's a peccary?"

"They're kind of like wild pigs. If you see any, don't get close. They can be mean."

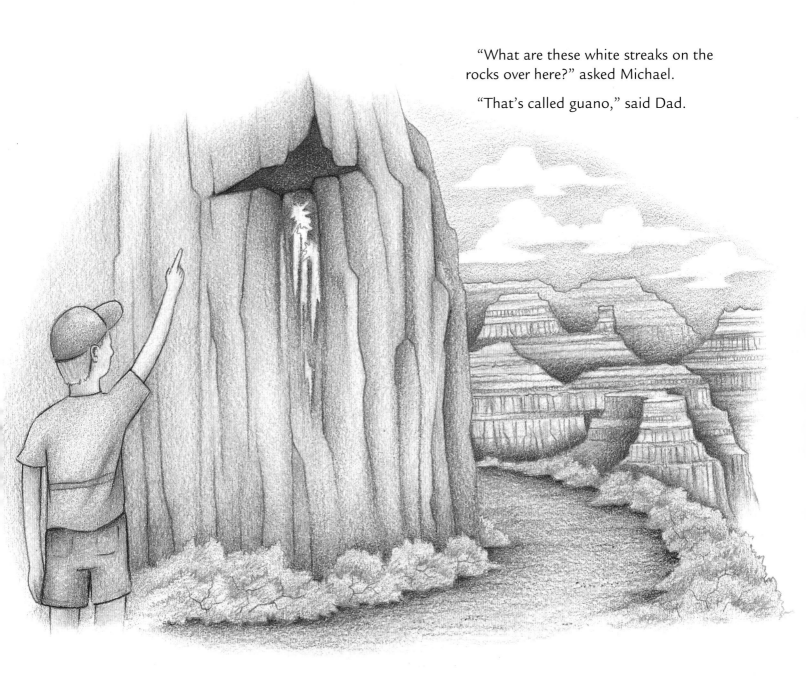

"What are these white streaks on the rocks over here?" asked Michael.

"That's called guano," said Dad.

"I know what that is!" exclaimed Emily. "We learned about it in school. Guano is bat poop!"

"Right," said Dad. "Here in Grand Canyon National Park you can find twenty different types of bats."

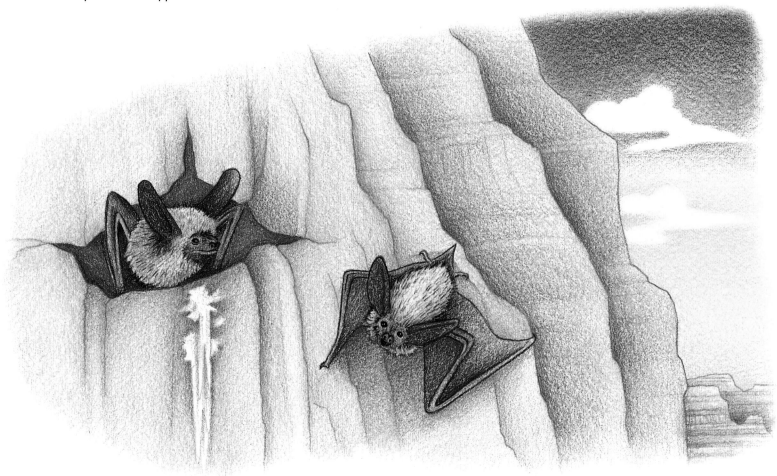

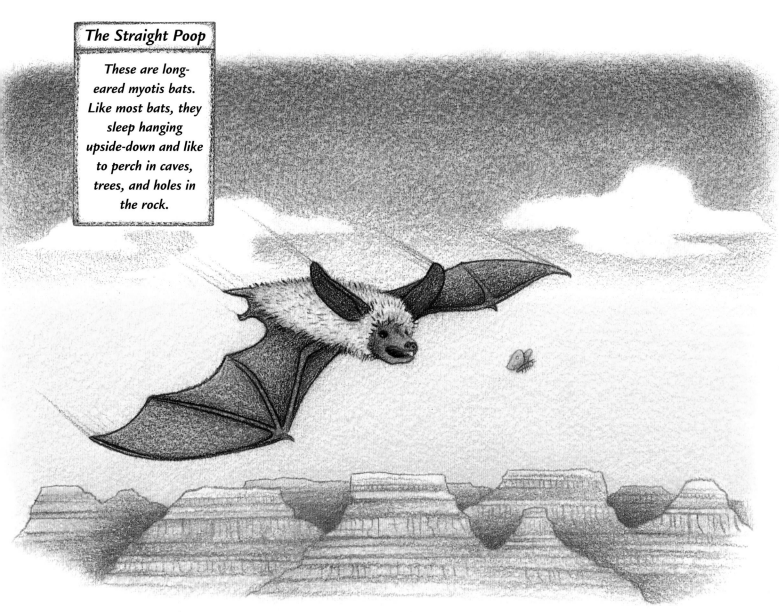

"These aren't vampires, are they?" said Michael with a shudder.

"No, these bats eat mostly bugs and fruit," said Dad. "There are no vampire bats around here."

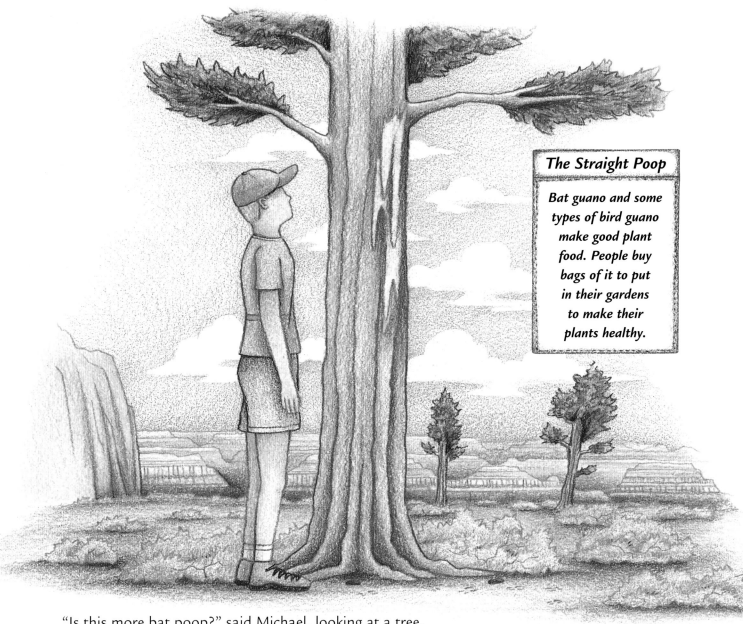

"Is this more bat poop?" said Michael, looking at a tree.

"No," said Mom. "It's from an owl. See these tracks with two toes pointing forward and two pointing backward, and the owl pellets around the base of the tree?"

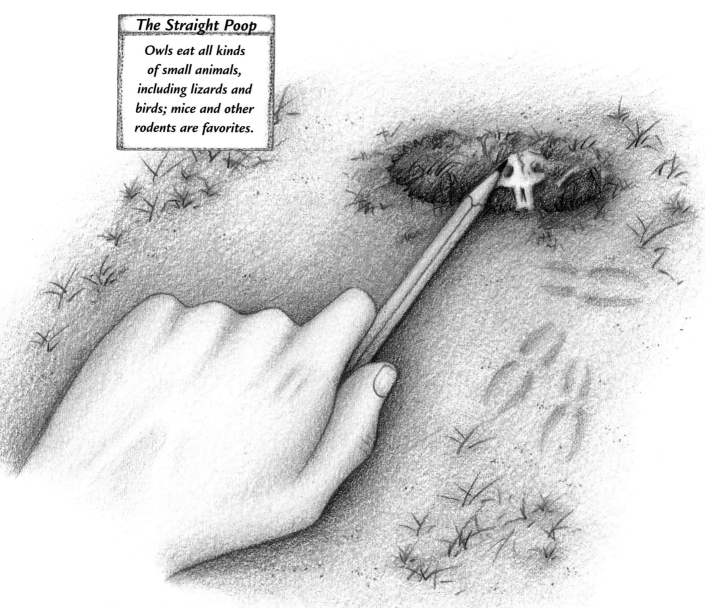

The Straight Poop

Owls eat all kinds of small animals, including lizards and birds; mice and other rodents are favorites.

"Owl pellets?" said Emily.

"Owls eat their prey whole," explained Mom. "The parts they can't digest, like hair and bones, get coughed up in a pellet like this."

"Yuck!" said Emily.

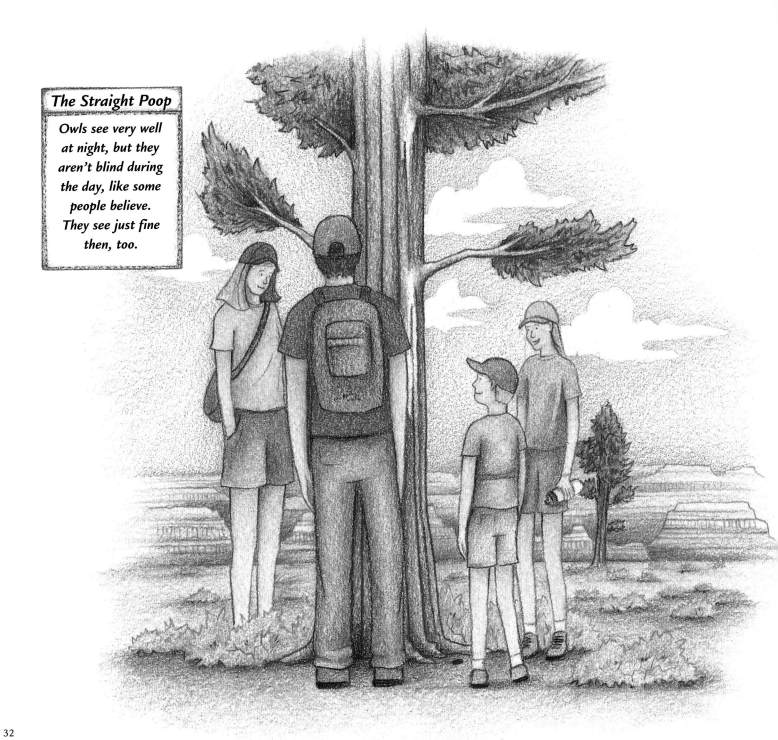

The Straight Poop

Owls see very well at night, but they aren't blind during the day, like some people believe. They see just fine then, too.

"You can tell this was a big owl by the size of the tracks and the pellets," said Mom. "The bigger the owl, the bigger the owl pellets."

"There are a bunch of different owls in Grand Canyon National Park," said Dad. "My favorite is the great horned owl."

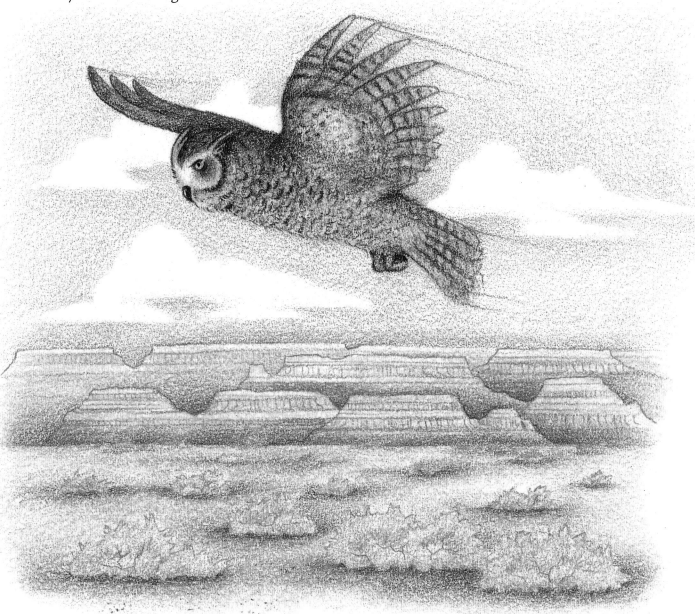

"This is a funny-looking track, Dad," said Michael. "It has more toes than the coyote track, and an extra part in the back, too."

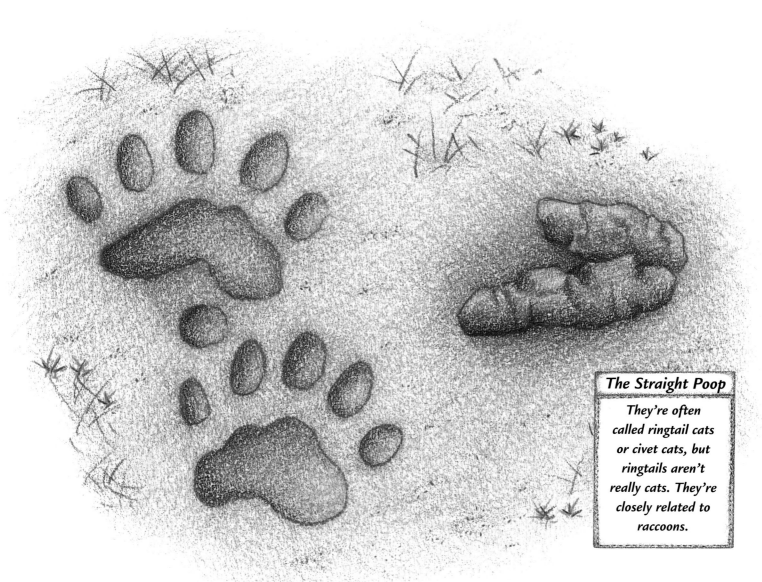

The Straight Poop

They're often called ringtail cats or civet cats, but ringtails aren't really cats. They're closely related to raccoons.

"That extra pad in the back gives it away," said Dad.
"These are from a ringtail."

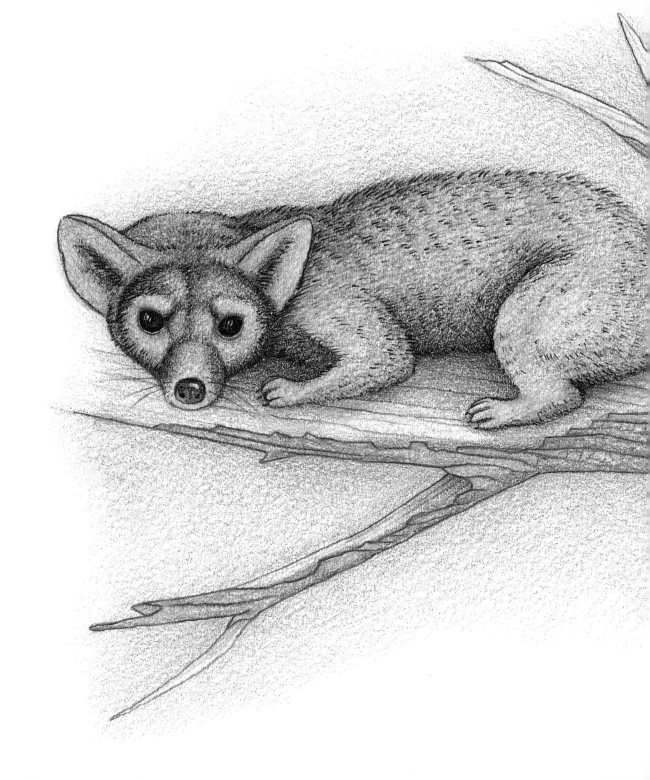

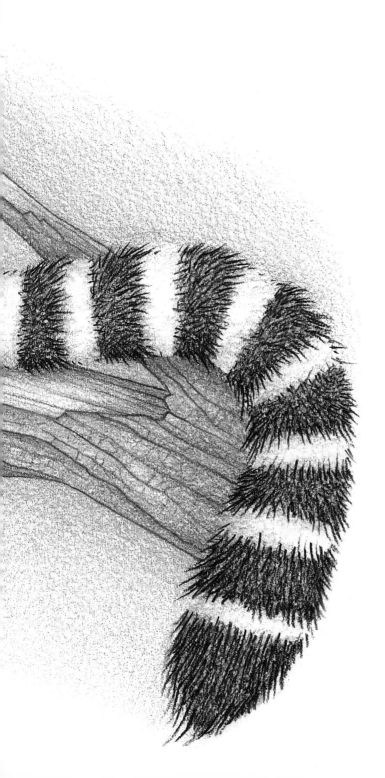

Emily's eyes lit up. "Ringtails are cool! I love their big eyes and long tails. Do you think we'll see one?"

"Probably not," replied Mom. "Ringtails are nocturnal, which means they sleep all day and come out at night."

"Look, everyone," Michael called out. "These tracks have four toes. There must have been more coyotes here."

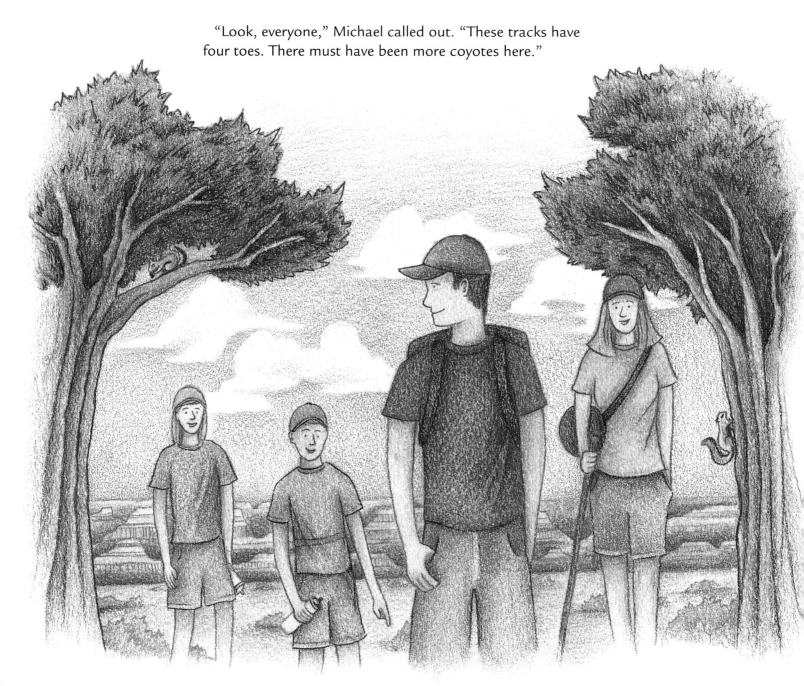

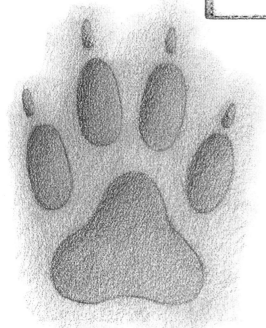

coyote track

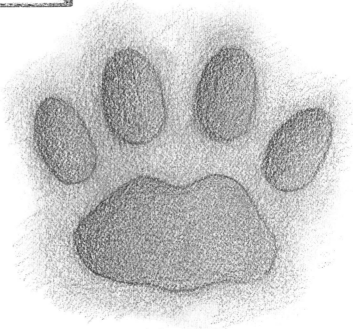

bobcat track

"That's not a coyote track," said Dad. "It doesn't show any claw marks, and the front of the big pad looks dented in."

"It's a bobcat track," said Mom.

"Here's another track just like it over here," said Michael. "But this one is huge."

"That's because the cat that made it is a lot bigger," replied Mom. "You found your mountain lion sign."

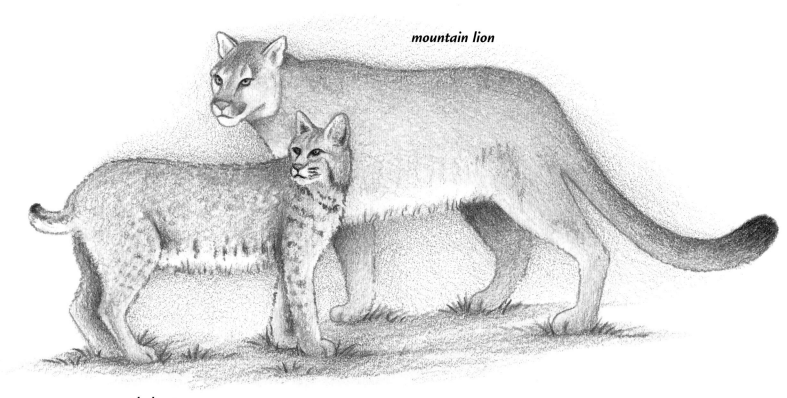

mountain lion

bobcat

"Let's see what you learned today," said Dad. "What can you figure out about this cat?"

"I see a bunch of scratch marks on this tree trunk," said Emily. "I think he used it like a scratching post to sharpen his claws!"

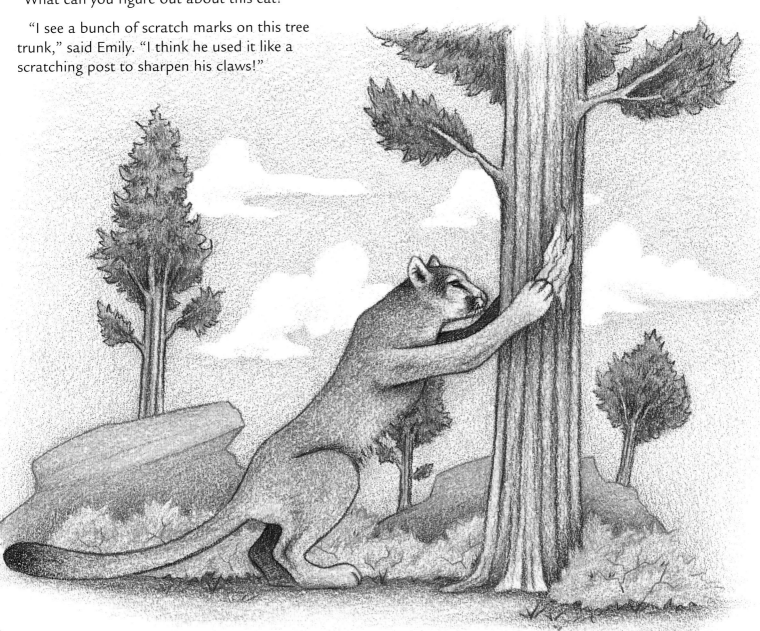

Mountain lions may be the biggest cats in North America, but they still bury their scat just like a housecat.

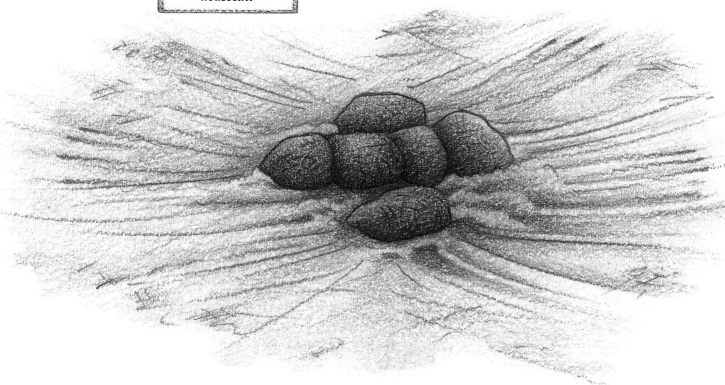

"Is this mountain lion scat?" asked Michael.

"It sure is," said Dad. "He tried to bury it, but the ground is too hard right here."

"It has bits of hair in it, just like the coyote scat," Michael pointed out. "They definitely eat meat."

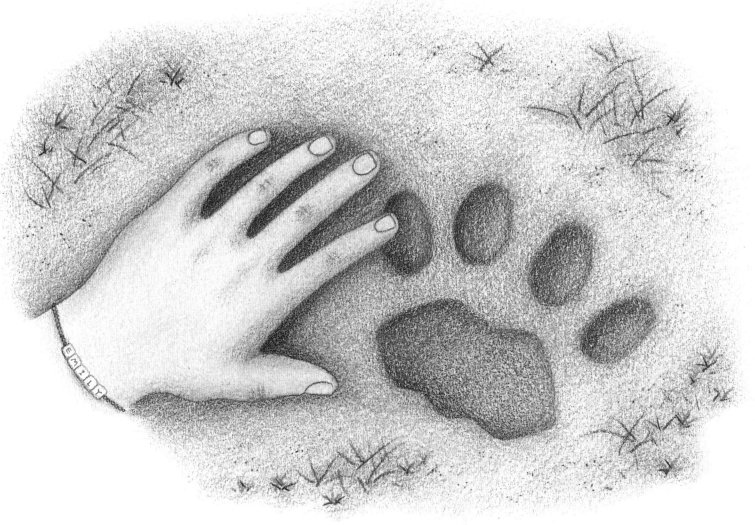

"He's awfully big," she said.

"That's right," Mom said. "A mountain lion weighs as much as I do, and a big one can weigh more than Dad!"

As they ate dinner that night, everyone talked about how much fun they had.

"We didn't see very many animals," said Emily, "but it seemed like we did."

"And I didn't get scared once," said Michael.

Tracks and Scat Notes

Bobcat
Tracks are very similar to a mountain lion's, but about half the size. Scat is usually buried.

Collared Peccary
Shorter stride than a deer. Tracks are usually six to ten inches apart. Scat is usually in large, uneven chunks.

Coyote
Tracks are like a dog's, with four toes, usually with visible claw marks. Scat is very dark colored with tapered ends and usually contains hair.

Desert Cottontail
Small tracks are filled in between the toes. The scat is in little balls.

Great Horned Owl
Tracks show four toes: two pointing forward and two pointing backward or to the side. Scat is runny and white. "Cough pellets" contain fur and bones.

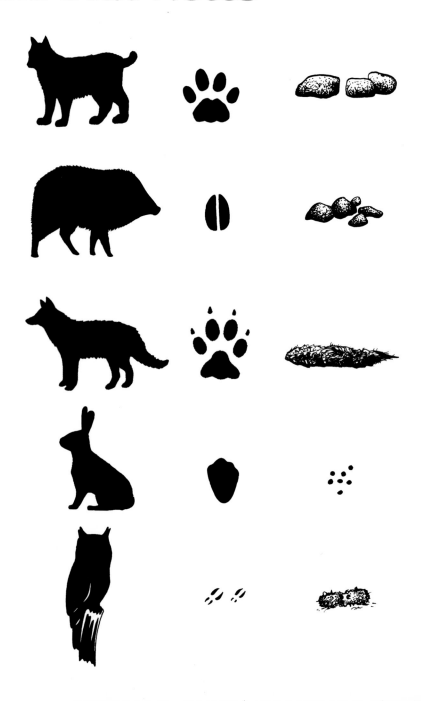

Tracks and Scat Notes

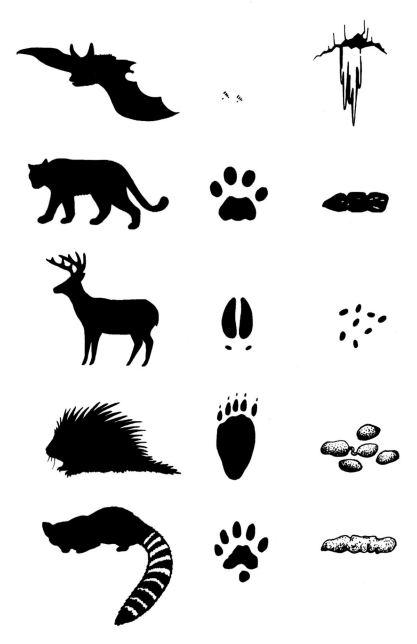

Long-Eared Myotis Bats
Bats rarely land on soft ground to leave tracks. Scat is runny and white.

Mountain Lion
Tracks are bigger than a coyote's, but claws don't show. Scat is rarely seen because they bury it.

Mule Deer
Pointy split-hoof tracks. Scat is long and oval-shaped like jellybeans, not round like a rabbit's.

Porcupine
Front track shows four toes, back track shows five. Tail drag marks are usually visible. Scat pellets are larger than deer scat.

Ringtail
Five toes on each foot. Front and back prints look alike. Claws don't show. Scat often has insects in it, and crumbles easily.

The Author

Gary Robson is a freelance writer who has written books for both children and adults as well as hundreds of magazine and newspaper articles. Gary is an expert in closed captioning technology for deaf people, and he has a teaching credential in computer science. He and his wife own a bookstore in Montana just outside Yellowstone National Park. For more about Gary, visit www.robson.org/gary.

The Illustrator

Elijah Brady Clark has been passionate about design and illustration for as long as he can remember. After living his dream of traveling the United States in an Airstream Bambi Travel Trailer, he returned to northwestern Montana's Flathead Valley, where he grew up. He currently works as a designer and illustrator.

OTHER BOOKS IN THE WHO POOPED IN THE PARK? SERIES:

Acadia National Park

Big Bend National Park

Black Hills

Colorado Plateau

Death Valley National Park

Glacier National Park

Grand Teton National Park

Great Smoky Mountains National Park

Northwoods

Olympic National Park

Red Rock Canyon National Conservation Area

Rocky Mountain National Park

Sequoia and Kings Canyon National Parks

Shenandoah National Park

Sonoran Desert

Yellowstone National Park

Yosemite National Park